# My Art and Coloring Style

My style can be summarized in three words: **animals**, **shapes**, **colors**.

My first source of inspiration is my love for animals. As a dog owner, I experience all the joy and happiness a pet can bring to humans. Unlike that grumpy colleague who depresses you with endless sad stories and complaints, animals always know how to lighten your day. Among my works of art, you wouldn't be able to find a painting without an animal included in the picture. Even when the main subject is not an animal, you will always find a little dog or a turtle somewhere in a corner.

I studied art at university, and I enrolled in the lace design specialist section. I haven't become a lace designer, but what I learned there helps me a lot in my work today. You can obviously see that my paintings are charged with details in a ton of different shapes, like a work of embroidery. I think that details add complexity and make paintings more interesting to view. For a part of my work, I also like doing research, and I am particularly inspired by historical art patterns and symbols. Putting these symbols into my designs enables me to convey different atmospheres and bring people into different worlds.

My optimistic nature needs to express itself, and I couldn't find a better way to do it than by putting colors on a piece of paper. I love to mix them and try to find new matches. I am always surprised at the way colors can form so many different impressions that I would never have imagined while I'm painting. I never know what my painting will look like in the end—I work spontaneously and always in a positive mood. My goal is really to make people happy by doing something that also makes me happy!

*My dogs, Kiwi and Max, always inspire me!*

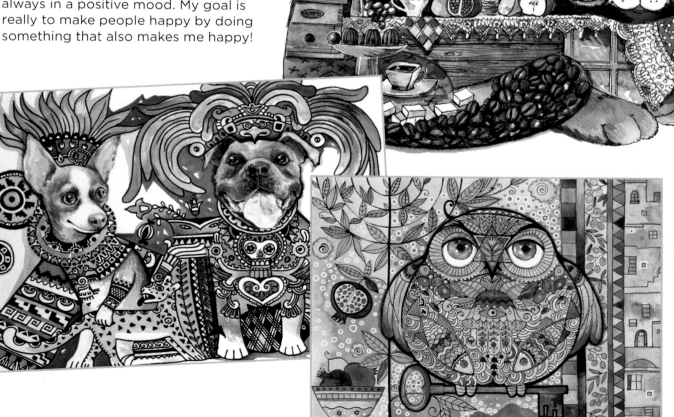

# Coloring Supplies

Here are some ideas for tools to use when coloring the art in this book or any coloring book.

**Colored pencils and markers.** This one is a no-brainer. You really don't have to buy an expensive colored pencil or high-end marker set for this coloring book. If you have kids, their colored pencils can be sufficient. And I can assure you that this coloring book will not register a complaint against you even if you fill it with ballpoint pen and nothing else!

**Fine-point pens and gel pens.** These are perfect for adding details or coloring small areas. Gel pens especially create nice, opaque lines on top of areas you've already colored.

**Watercolor.** The truth is I love watercolor. I love how unpredictable it can be, especially when you add a lot of water—the color flows, and you never know exactly how it will look in the end. It is perfect for backgrounds when done with a medium-large brush. But you can also use it for more detailed shapes. Just remember to let the background dry before adding detail. Use less water and a smaller brush for more vibrant colors.

**Watercolor pencils.** These are great for people who don't want to jump right into watercolor but still like the effect. You know those visible stroke marks that your pencils sometimes leave when you color a large surface? If those annoy you, watercolor pencils are the perfect choice. Once you color a surface, take a small brush, dampen it, and apply it to the colored surface. The color will transform into watercolor paint, and you can brush and blend it to make the strokes disappear. Flawless!

**Weird stuff.** Do you feel desperate because you have nothing at home that's inspiring you, but you want to start coloring anyway? Why not have some fun and try some think-outside-of-the-box materials? Beetroot has a really strong and beautiful color. Green leaves have a lot of chlorophyll in them—if you rub them on your paper, they can give you surprising results. Do you think that these coloring tool suggestions are strange? Well, they are, but my point is that you should be free, be imaginative, and do what you like!

> For best results, if you want to use a lot of watercolor on a design from this book, photocopy the design onto thicker watercolor paper. At the very least, you should remove the design from the book before you start coloring with watercolor.

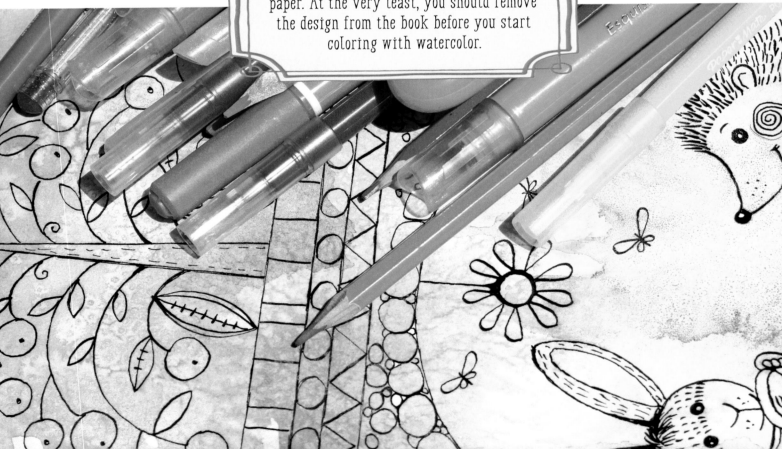

# Tips and Ideas

If you feel you need more direction before you get coloring, or even after you've been coloring for a while, I know you'll find some inspiration here!

**Embrace mistakes.** "Oops, I spilled some coffee on my painting, let's put it in the trash and start another one"—nope! Coffee, as well as tea, actually has a nice color. Instead of bemoaning your lost piece, think creatively. You can take a damp brush and extend this light yellowish brown, or blot some of it off and let the rest dry as is. Be spontaneous, and never think that your painting is failed. In art, there are no mistakes—only innovation. And if you think I'm kidding about this coffee idea, turn the page and see for yourself!

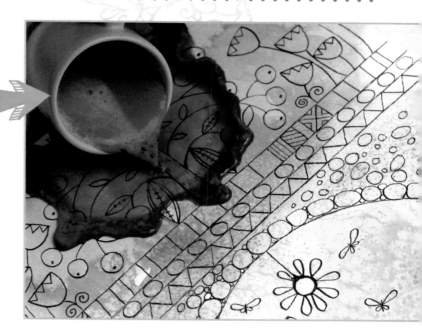

**Art is not a precise science.** Follow your emotions, your instincts, your spontaneity. If you need rules, detailed instructions, and precise steps to follow, go and buy a puzzle book. This is the difficulty and the marvel of art. You can try to paint your emotions, your feelings—what colors do you associate with how you feel right now? You can experiment with colors that you don't think will match. You can follow the lines of the designs in this book, or you can cross the borders. You can also add your own shapes and details. The most important thing is not to be afraid. You will be pleasantly surprised at the result if you don't painstakingly plan out what you're doing. The worst that can happen is you won't like the result. It happens to me plenty, but then I am surprised to hear compliments on paintings I thought turned out badly.

**Take a look in the mirror.** Seeing your painting in reverse can give you ideas. I often do this to have a unique look at my work; it really helps me see what is missing, what color or shape I can add and where. Part of the reason this can work is because in the mirror you aren't as distracted by the main image, which is often flipped beyond recognition.

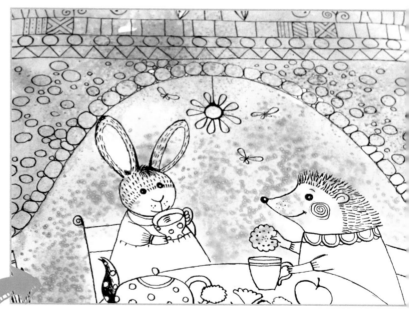

**Try using salt.** You can use salt to add an interesting texture to your painting if you're using watercolor or watercolor pencils. While the paper is still wet, put some salt on it where you want the texture to appear. Then let the piece dry without touching it. When it's completely dry, brush off the salt and contemplate the amazing result.

**Forget reality.** Apples don't have to be red, and lemons can be blue. Don't limit yourself. In my opinion, coloring books are made for breaking the rules. So use all the colors of the rainbow, anywhere!

**The "no black" rule.** Speaking of color… When I was a student, our teachers told us to do whatever we wanted, except use black. Technically, black is not even a color, but rather the absence of light! Now, I don't have anything against black. But too much black is likely to make your coloring look sort of dirty, and it is difficult to correct mistakes made with black, so I suggest using it sparingly. Again, though, if you feel confident or inspired using black, go for it.

# Follow Along Coloring

Here is a step-by-step example of me coloring one of my drawings. Hopefully you can be inspired to start working on your own colorings.

> Remember: You can use whatever tools you like in place of the ones that I chose to use here. For example, you can color the background in colored pencil instead of watercolor!

**1.** Here is the black and white design I am using. I love the little vignette it presents of two friends enjoying teatime!

**2.** I'm starting the background using one color at the top. I'm using light watercolors, but you can also use a colored pencil or watercolor pencil with very light pressure to get a background effect similar to mine.

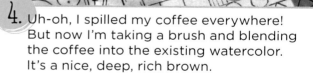

**3.** I've colored the background using three different colors, and I've added some salt. I used a lot of water to make the colors light. Whether you're coloring with watercolor, colored pencil, marker, or something else, it's important to keep your background light enough for your main design to stand out.

**4.** Uh-oh, I spilled my coffee everywhere! But now I'm taking a brush and blending the coffee into the existing watercolor. It's a nice, deep, rich brown.

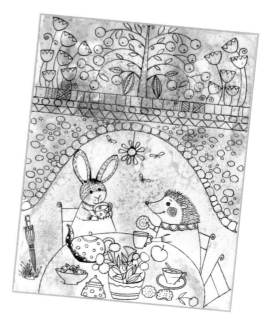

**5.** Now I've completely finished my background, including the coffee spill. If you're using watercolor and feel that you flooded your paper, you can use a tissue to mop up the excess water, which will lighten the color as well. Time to let it dry completely before proceeding!

**6.** Now that the piece is dry, I'm starting to color details. A good way to do this is to start with the more general, larger details and progress to the more particular, tiny details. You can add details almost endlessly—only you decide when to stop.

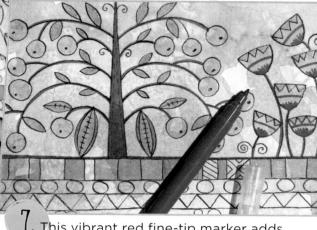

**7.** This vibrant red fine-tip marker adds deep color to the tree at the top and the flowers next to it.

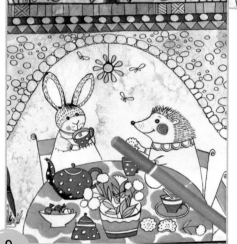

**8.** I liked the watercolor pink I had on the table, so I've added darker pink details with a marker.

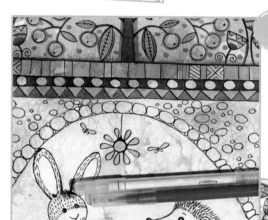

**9.** Time for some different fine-tip markers to add more color to the small details, including some cute polka dots on the table and hearts in the hedgehog's collar.

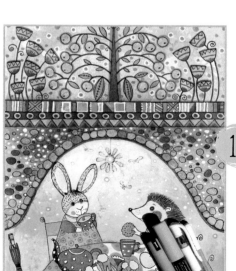

**10.** Now I'm using a white gel pen and green and blue paint pens to add a ton of delicate detail work and patterning, especially in the borders along the top.

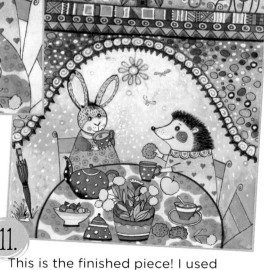

**11.** This is the finished piece! I used lots of different tools and had so much fun doing it.

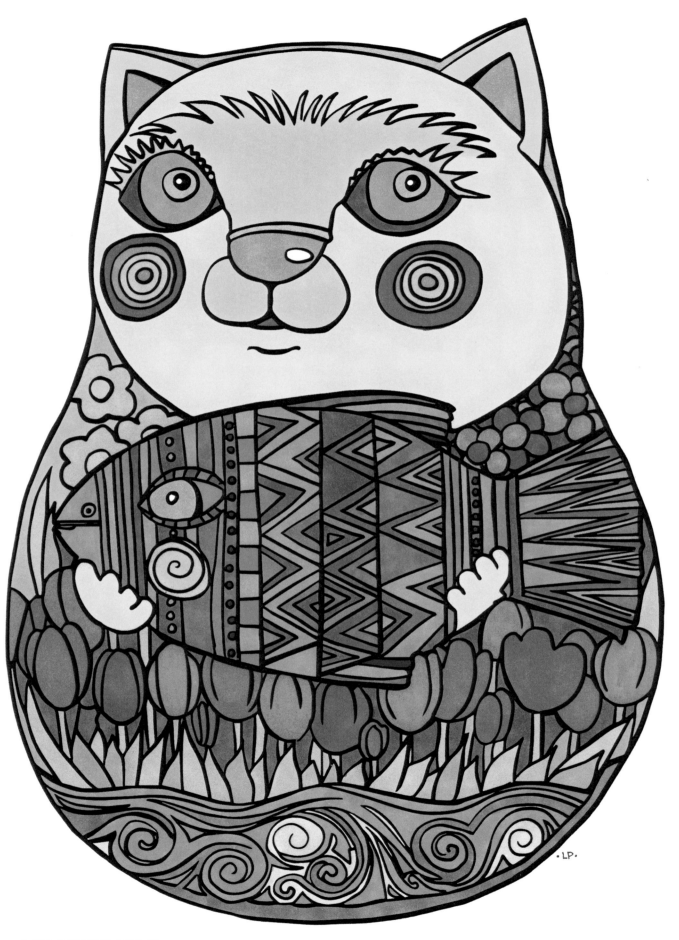

*A Fish in the Paw, page 43.*

6   *Markers (Chameleon, Ironlak). Color by Llara Pazdan.*

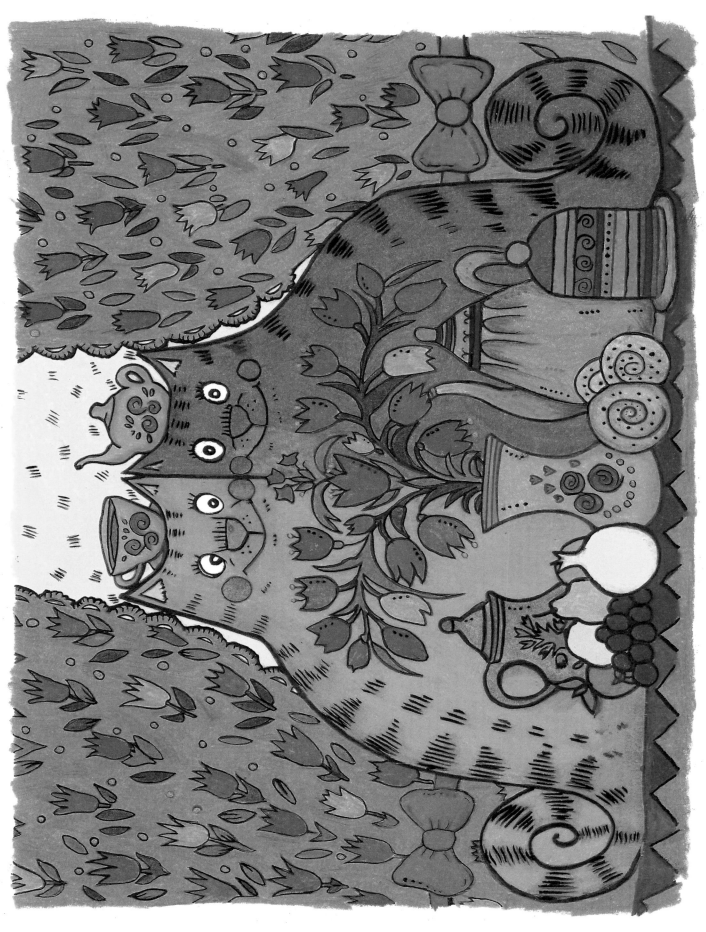

*Tea Party, page 37.*
*Colored pencils (Prismacolor). Color by Kelly Nagorka.*

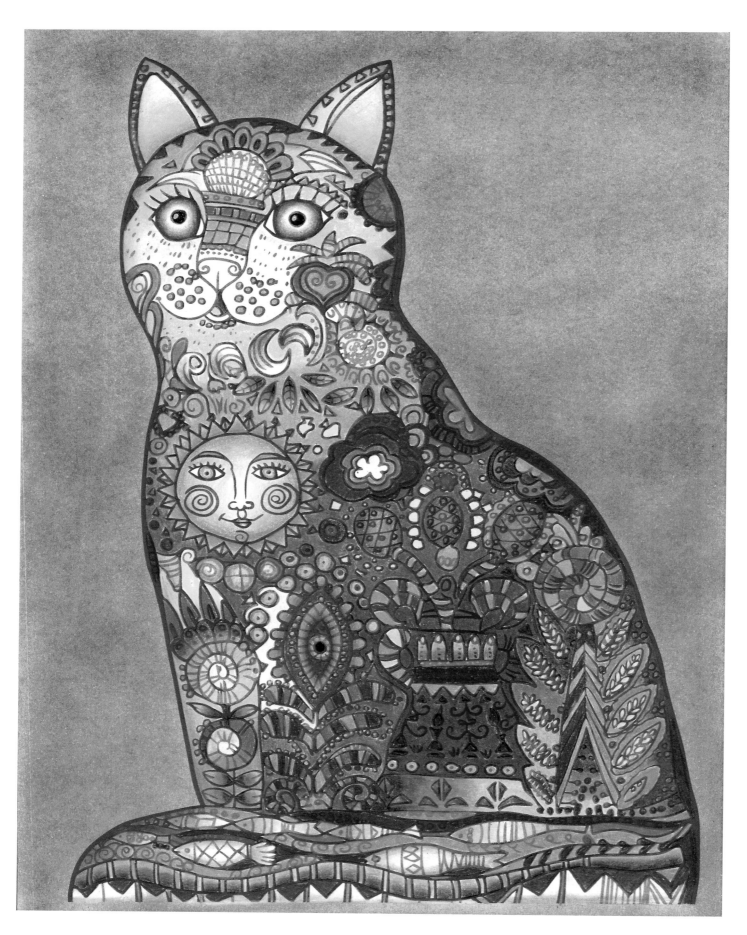

*Potential Energy, page 29.*

*Colored pencils (Prismacolor), soft pastels (Mungyo). Color by Keara Irby.*

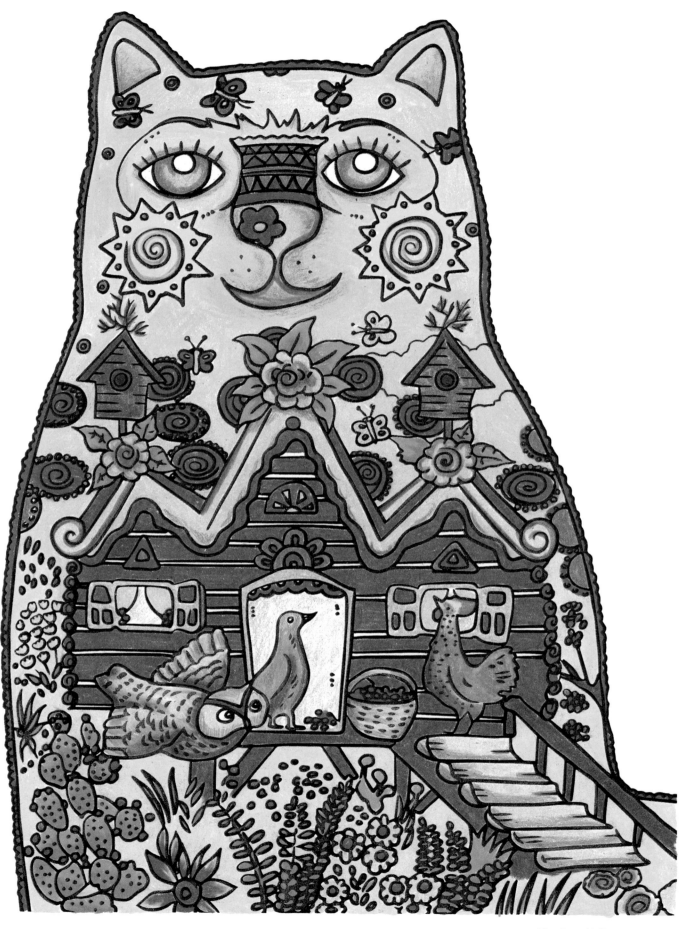

*The Good Life, page 47.*
*Colored pencils (Prismacolor). Color by Sarah von Schmidt-Pauli.*

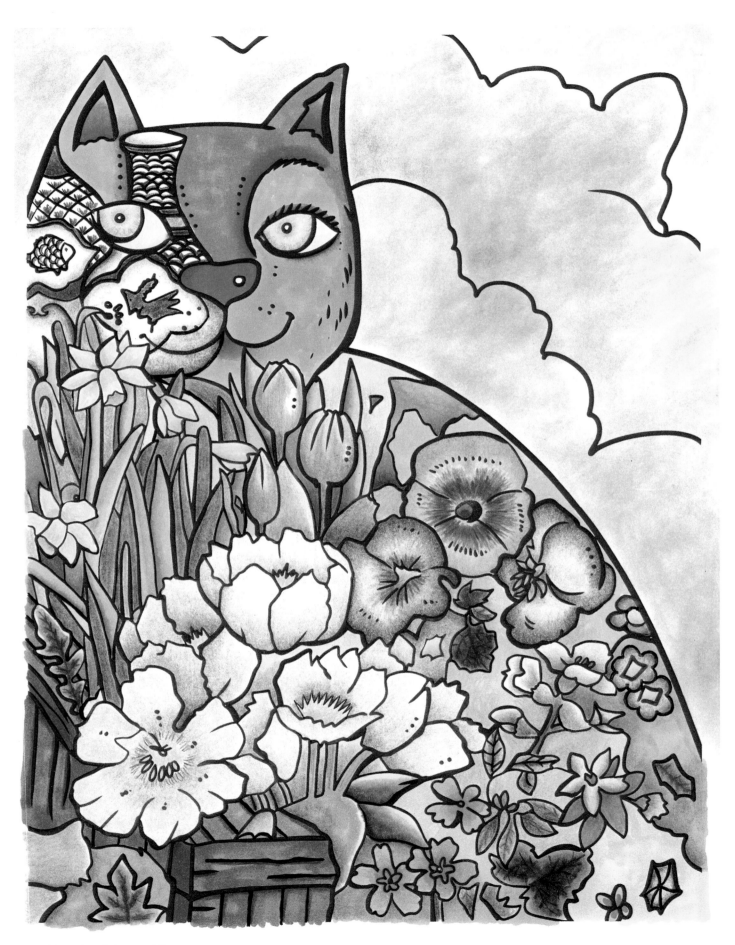

*Blooming Cat, page 39.*

*Markers (Spectrum Noir), colored pencils, pens (Pigma Micron), soft pastels. Color by Lisa Caryl.*

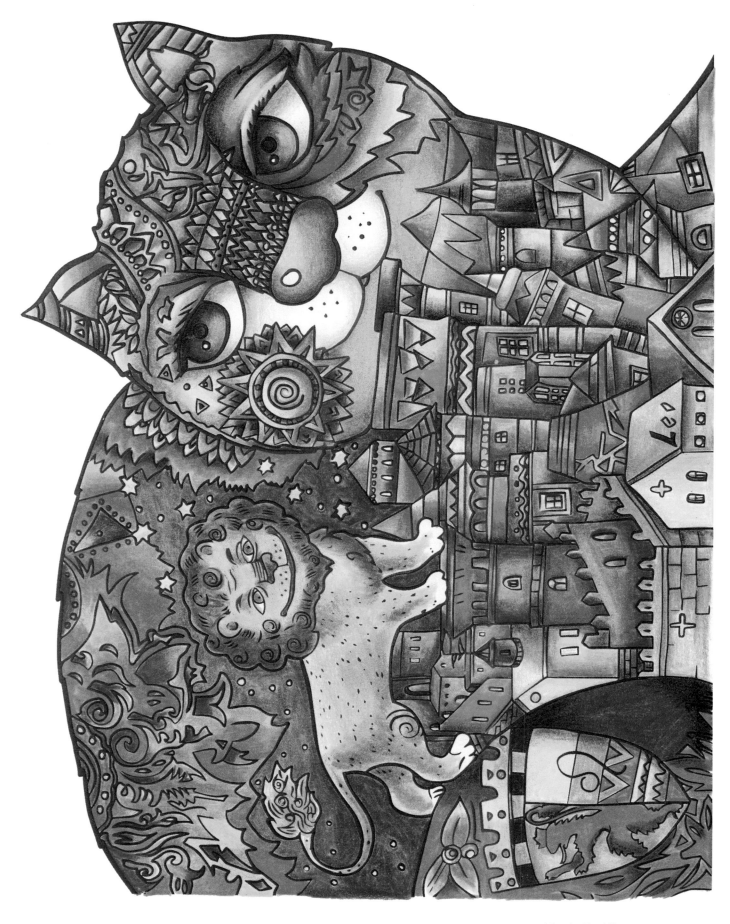

*Lion in the Mirror, page 45.*
*Colored pencils. Color by Roslyn Coronado.*    11

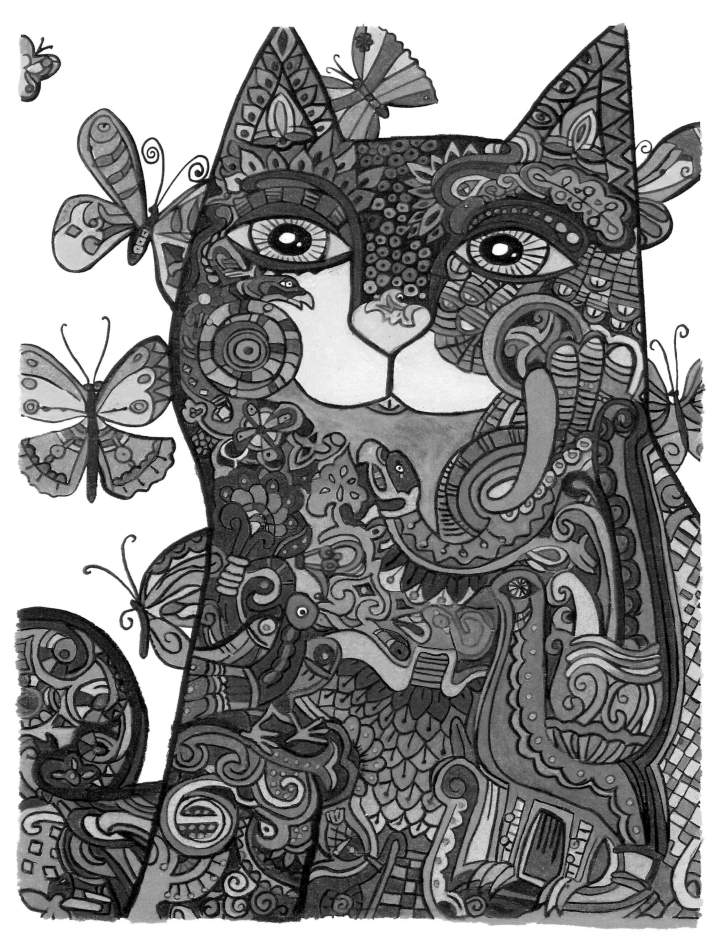

*Southwest Cat, page 35.*

12     *Colored pencils (Prismacolor). Color by Kelly Nagorka.*

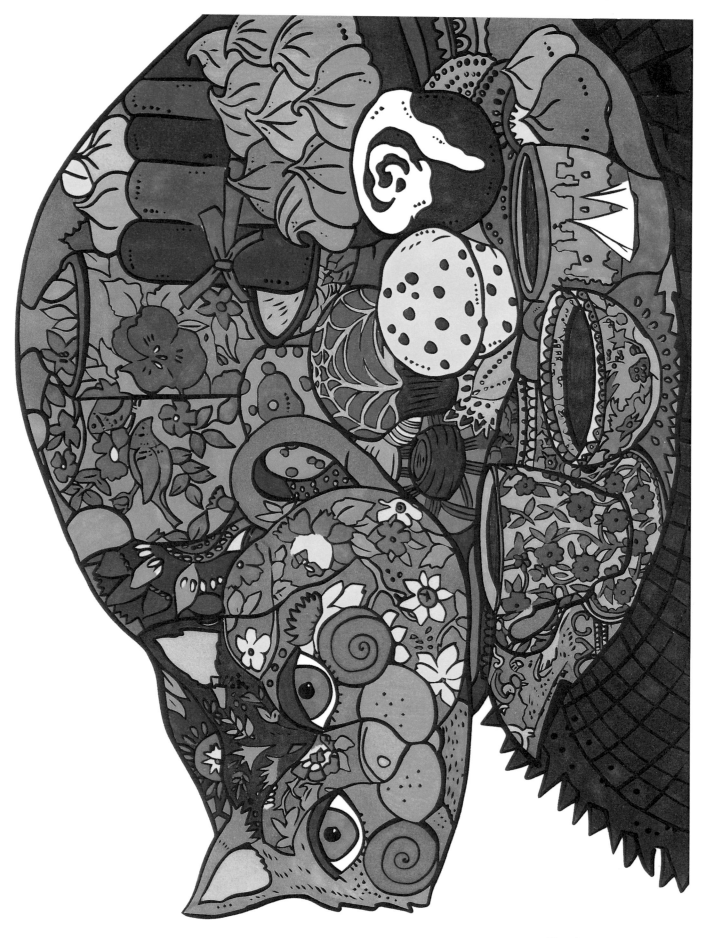

*Time for Tea, page 33.*
*Markers (Sharpie). Color by Annie Jump.* 13

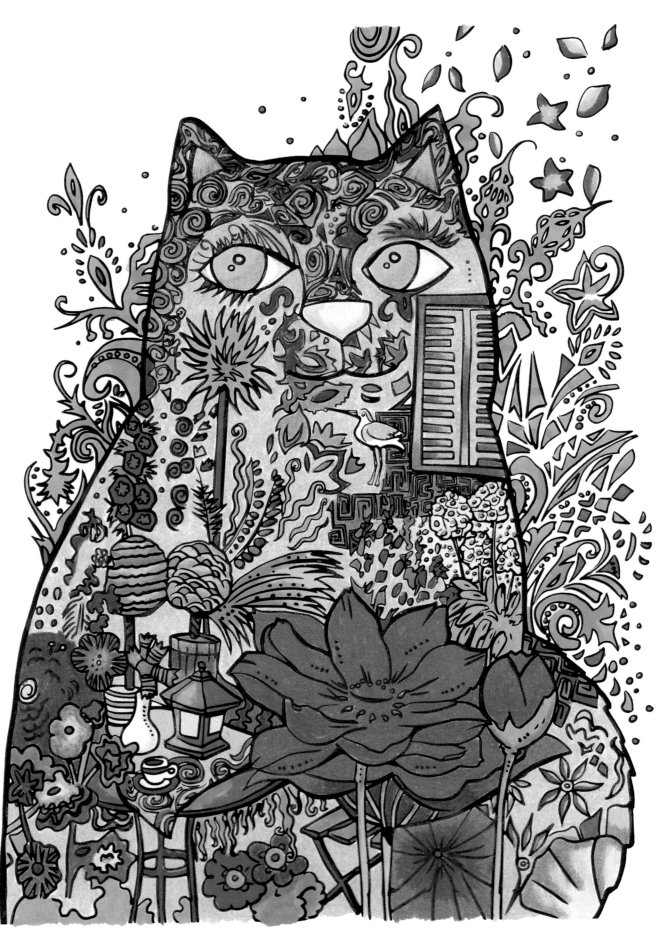

*Contemplative Cat, page 27.*

*Colored pencils (Prismacolor). Color by Nichole Warman.*

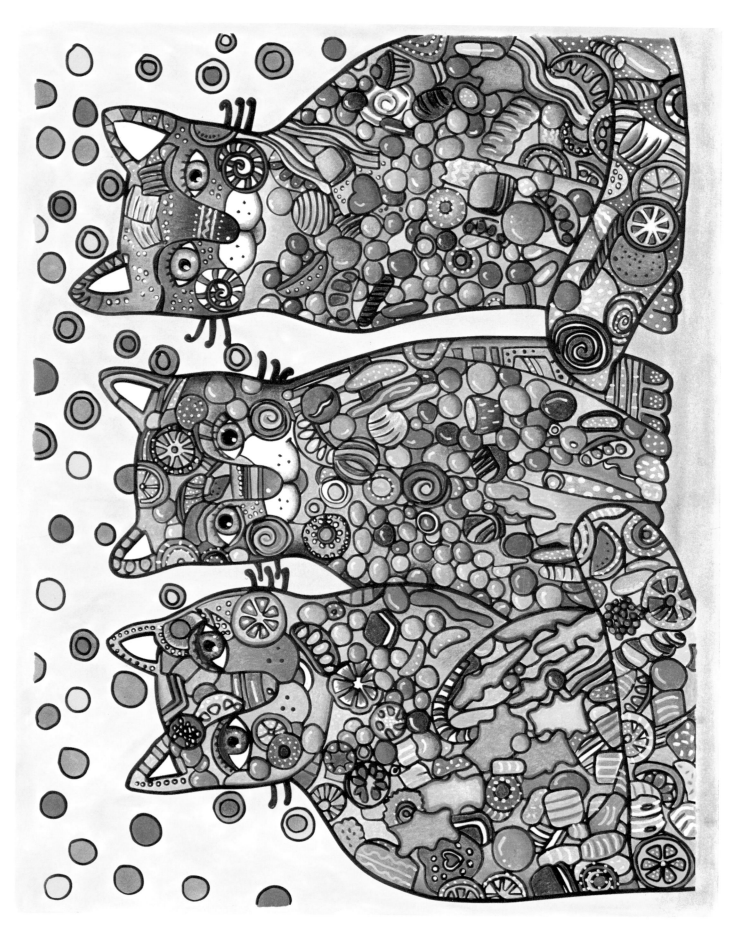

*Kitty Candy, page 41.*
*Colored pencils (Prismacolor), markers (Spectrum Noir), white paint pen (Sakura), soft pastels. Color by Lisa Caryl.* 15

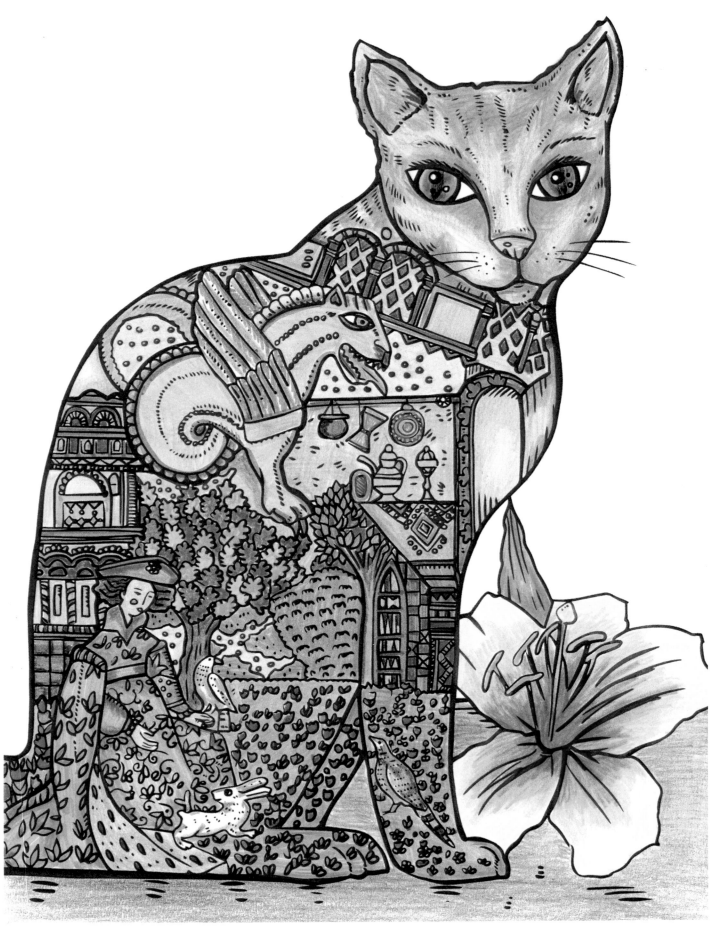

*Where There's a Will There's a Cat, page 17.*
*Colored pencils (Crayola), markers (Crayola). Color by Darla Tjelmeland.*

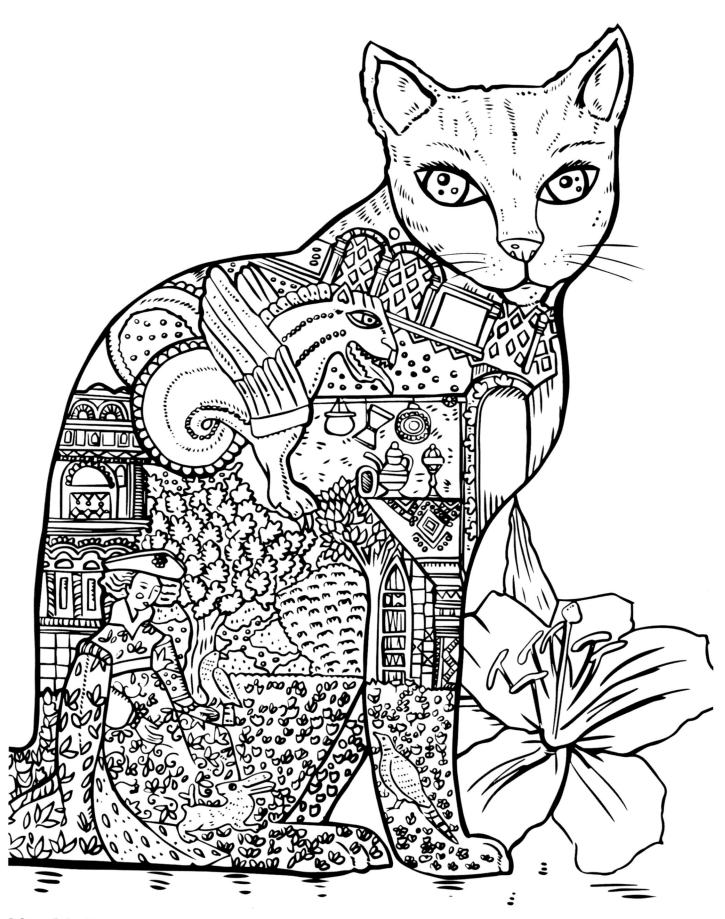

The mathematical probability of a
common cat doing exactly as it pleases is the
one scientific absolute in the world.

—Lynn M. Osband

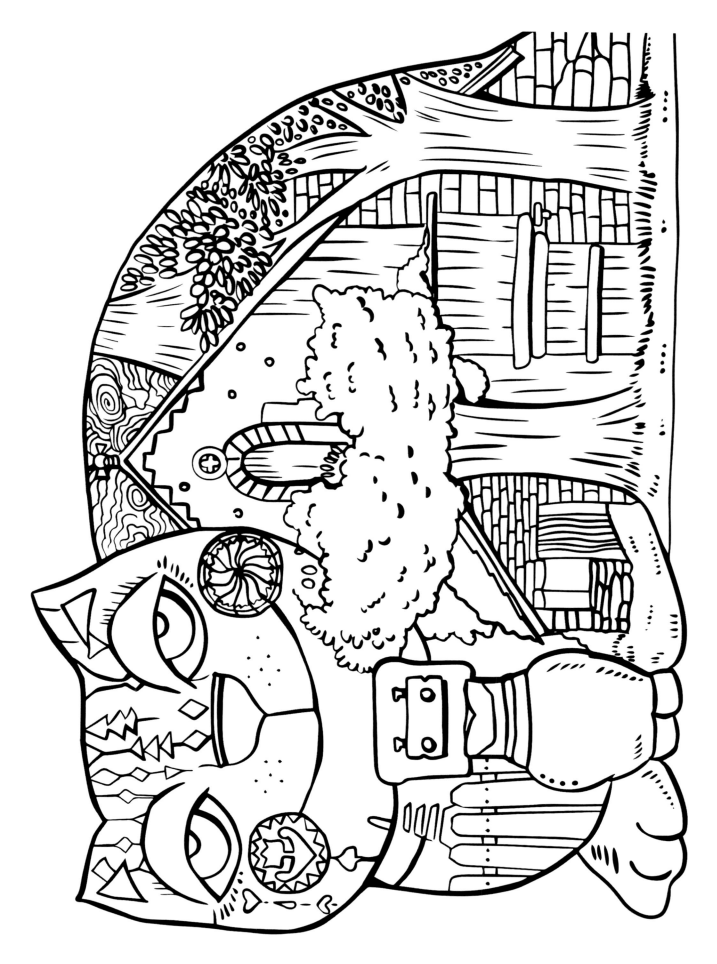

There are few things in life more heartwarming than to be welcomed by a cat.

—Tay Hohoff

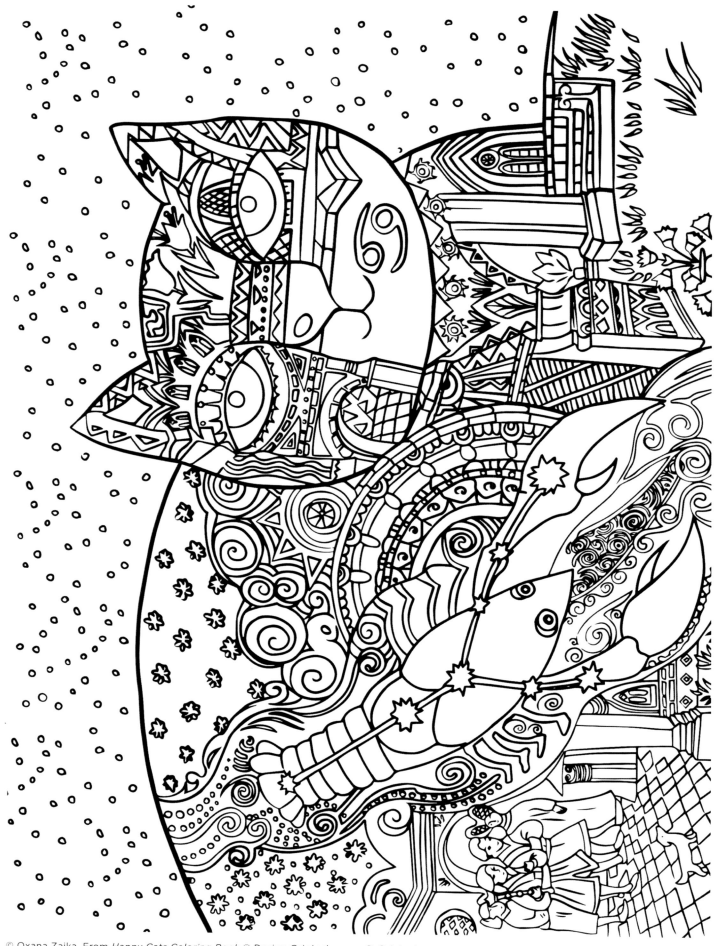

With their qualities of cleanliness, discretion, affection, patience, dignity, and courage, how many of us, I ask you, would be capable of becoming cats?

—Fernand Méry

The Lobster

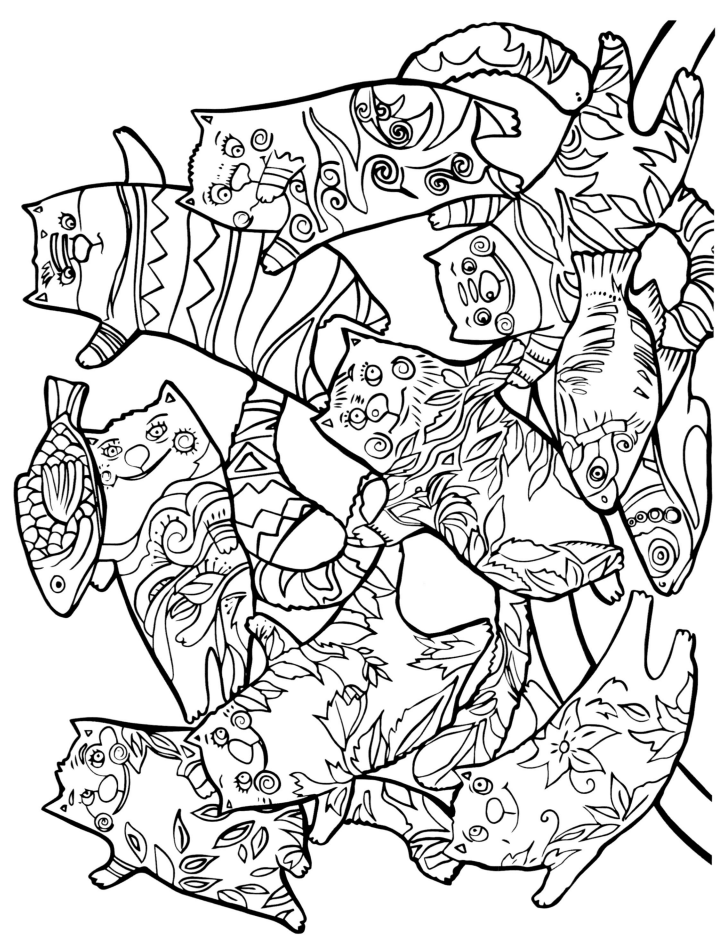

Cats do not have to be shown how to have a good time, for they are unfailing ingenious in that respect.

—James Mason

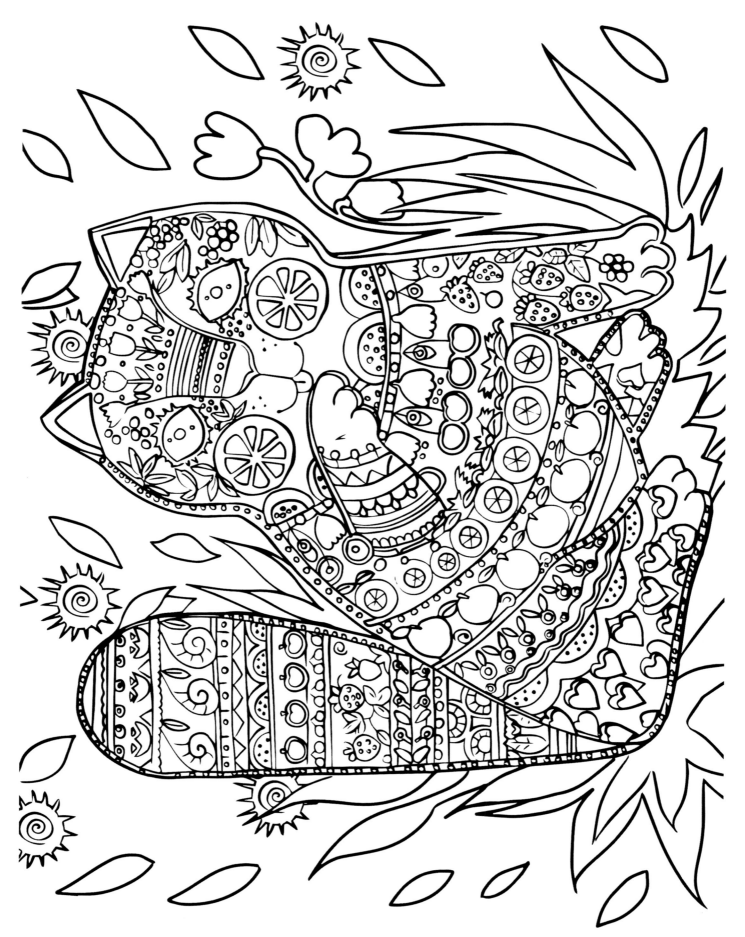

Any glimpse into the life of an animal
quickens our own and makes it so much the
larger and better in every way.

—John Muir

Fruit Kitty

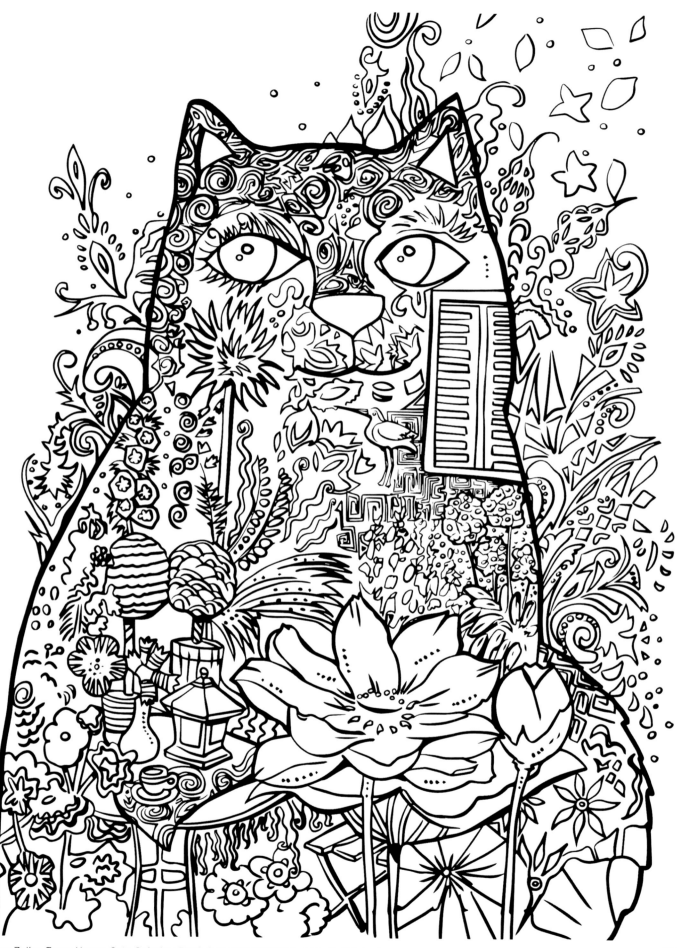

I think having an animal in your life
makes you a better human.

—Unknown

Contemplative Cat

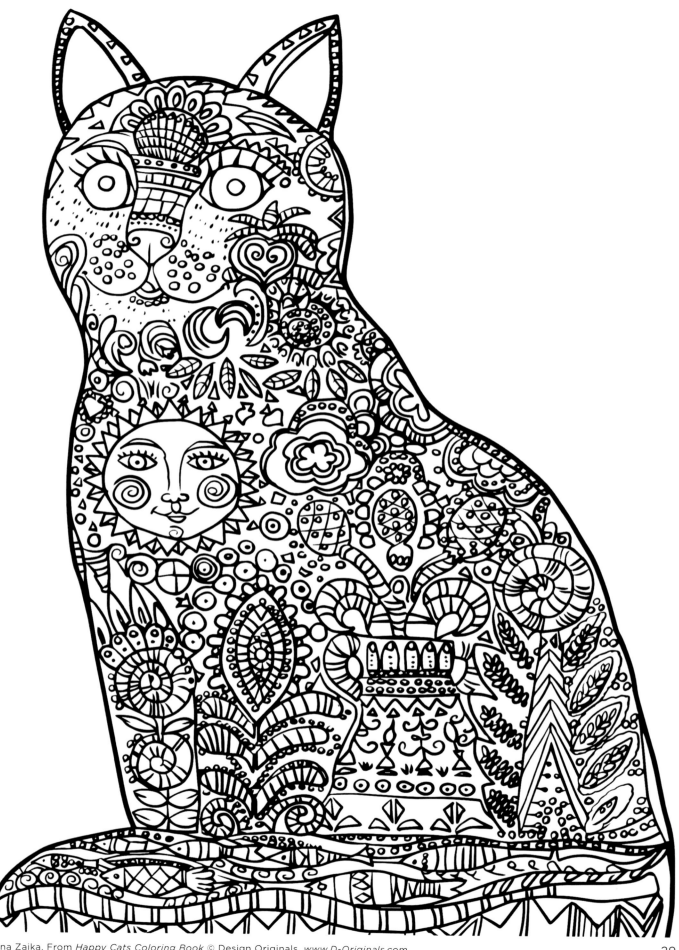

The ideal of calm exists in a sitting cat.

—Jules Renard

Potential Energy

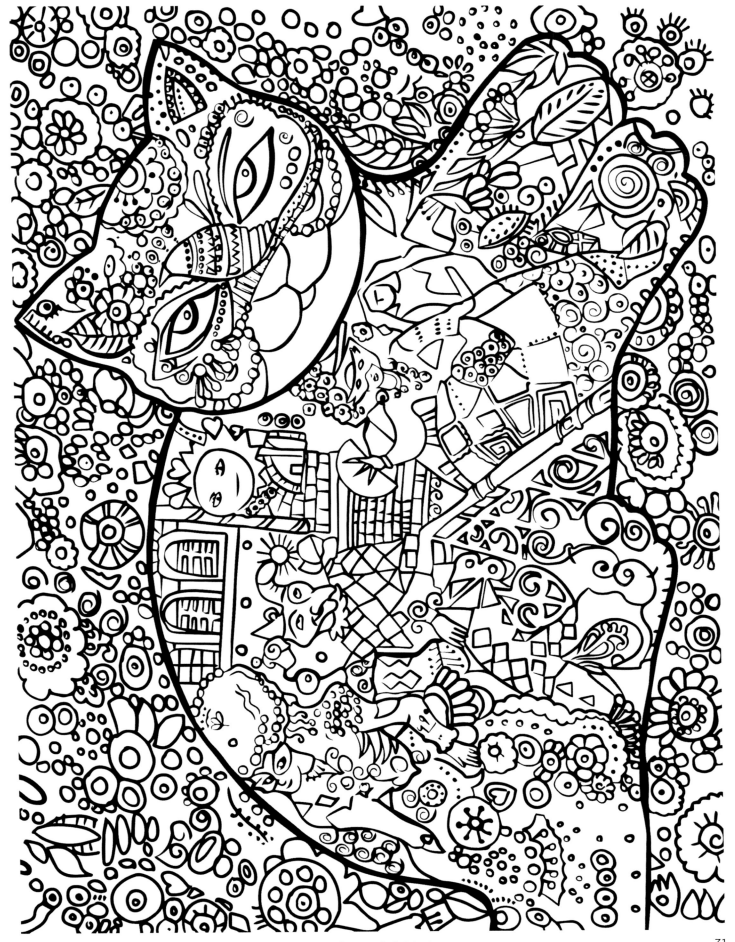

Cats are a mysterious kind of folk—
there is more passing in their minds
than we are aware of.

—Sir Walter Scott

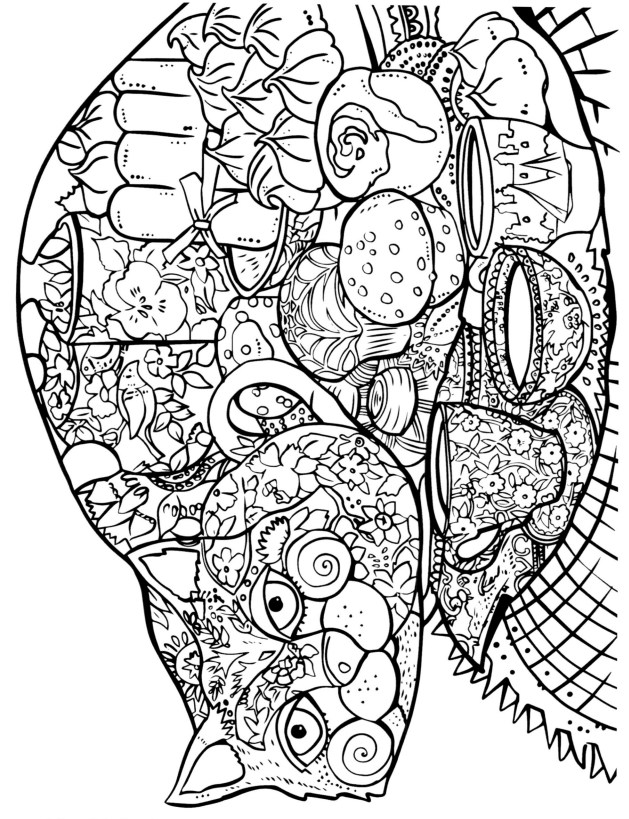

© Oxana Zaika. From *Happy Cats Coloring Book* © Design Originals, *www.D-Originals.com*

I take care of my flowers and my cats.
And enjoy food. And that's living.

—Ursula Andress

Time for Tea

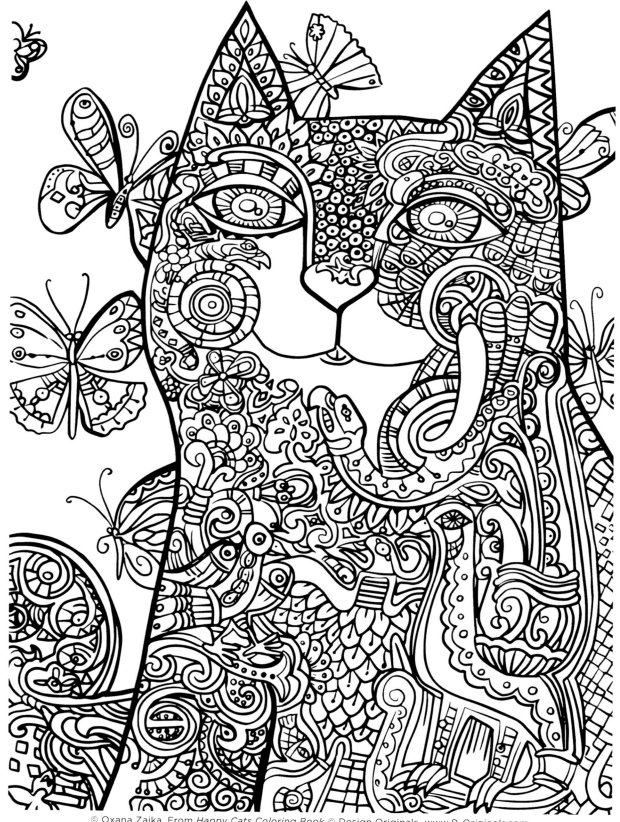

© Oxana Zaika. From *Happy Cats Coloring Book* © Design Originals, *www.D-Originals.com*

I believe cats to be spirits come to earth.
A cat, I am sure, could walk on a cloud
without coming through.

—Jules Verne

Southwest Cat

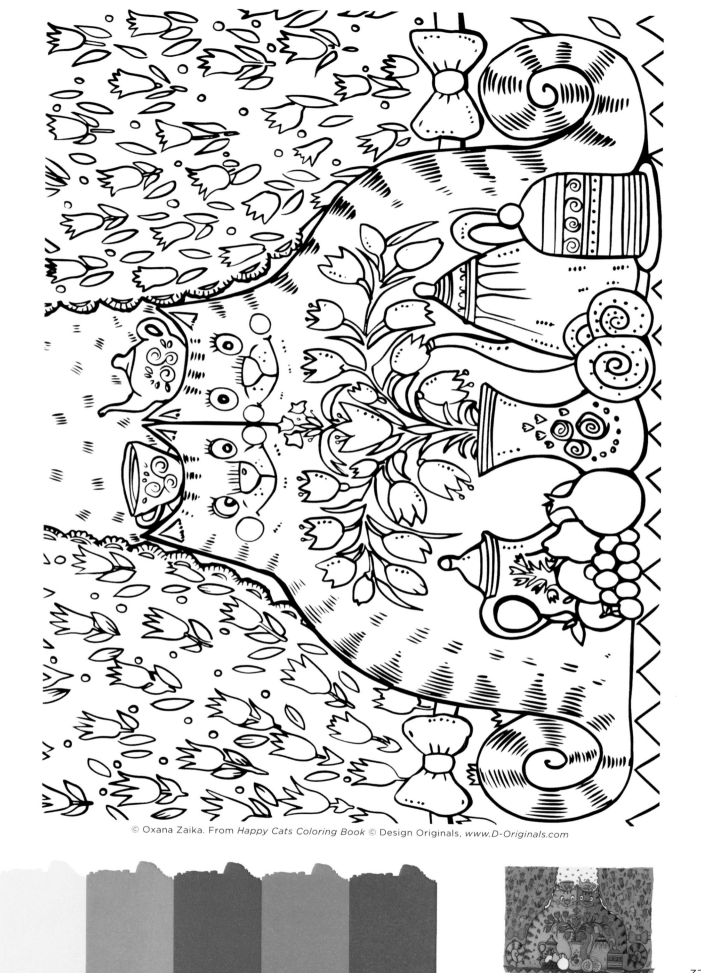

© Oxana Zaika. From *Happy Cats Coloring Book* © Design Originals, www.D-Originals.com

The greatest escape from your worries are cats,
music, coffee or tea, and books.

—Unknown

Tea Party

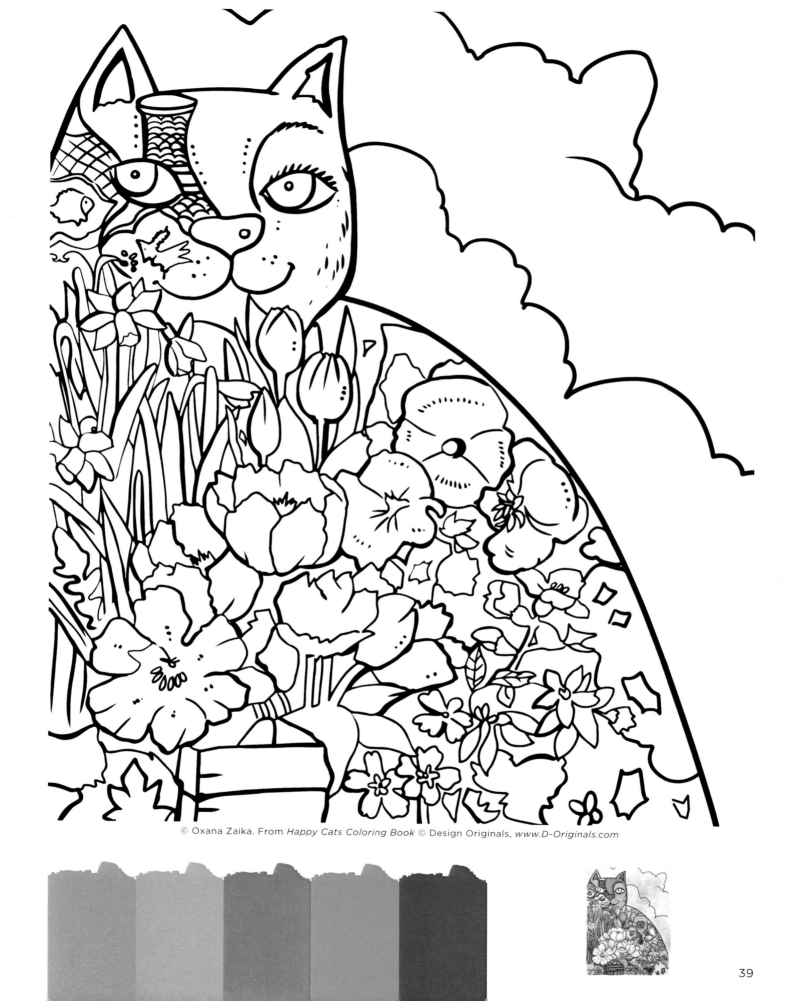

© Oxana Zaika. From *Happy Cats Coloring Book* © Design Originals, *www.D-Originals.com*

Cats never strike a pose that isn't photogenic.

—Lilian Jackson Braun

Blooming Cat

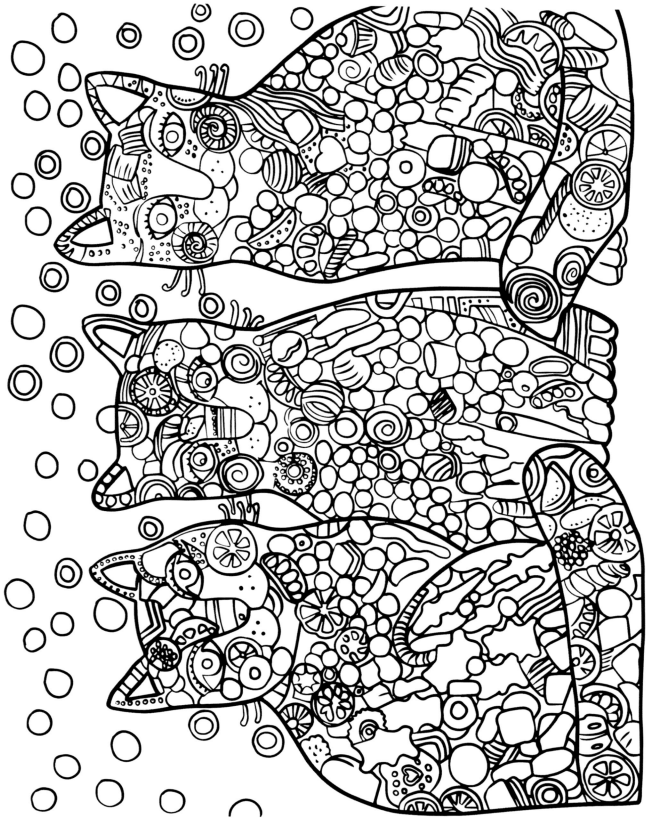

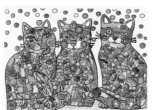

I have lived with several Zen masters—
all of them cats.

—Eckhart Tolle

Kitty Candy

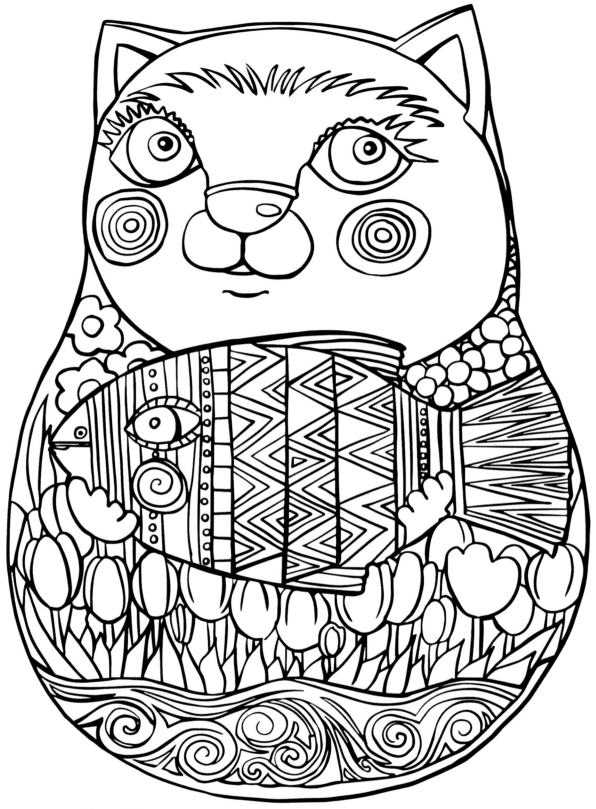

It is not about how much we have,
but how much we enjoy, that makes happiness.

—Charles Spurgeon

A Fish in the Paw

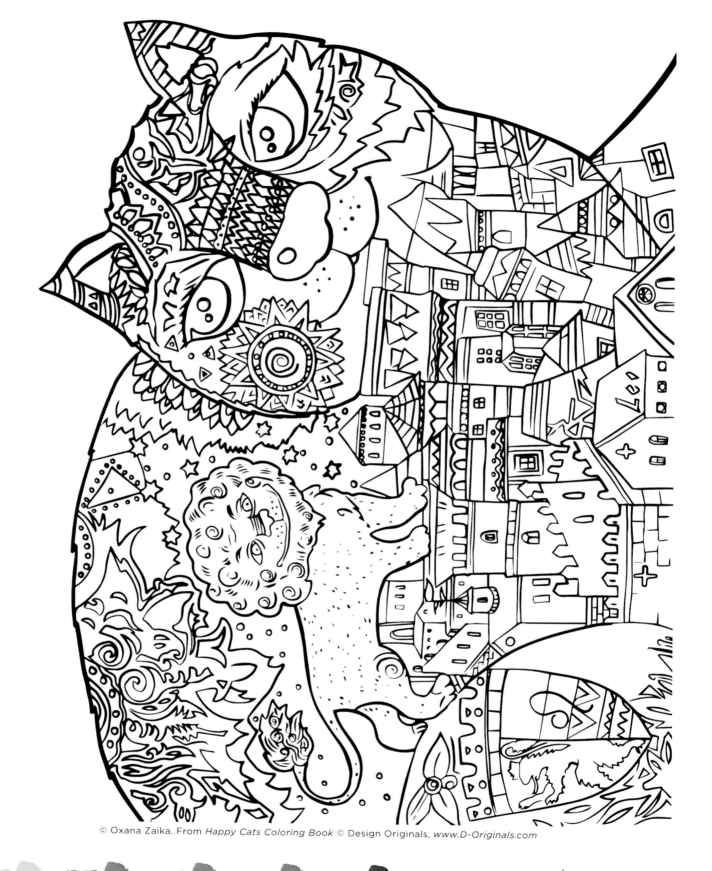

© Oxana Zaika. From *Happy Cats Coloring Book* © Design Originals, *www.D-Originals.com*

Prowling his own quiet backyard or
asleep by the fire, he is still only a
whisker away from the wilds.

**—Jean Burden**

Lion in the Mirror

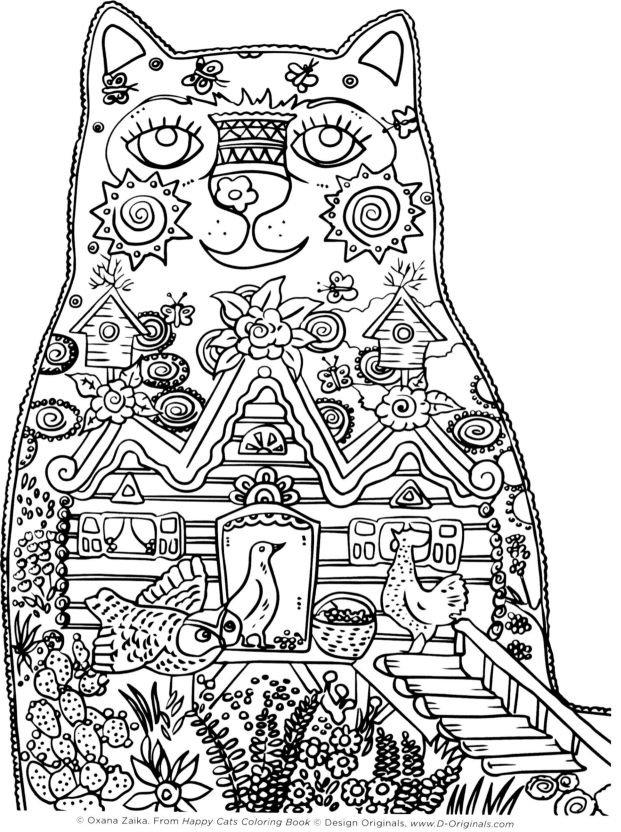

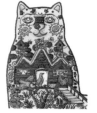

Cats, I think, live out their lives
fulfilling their expectations.

—Irving Townsend

The Good Life

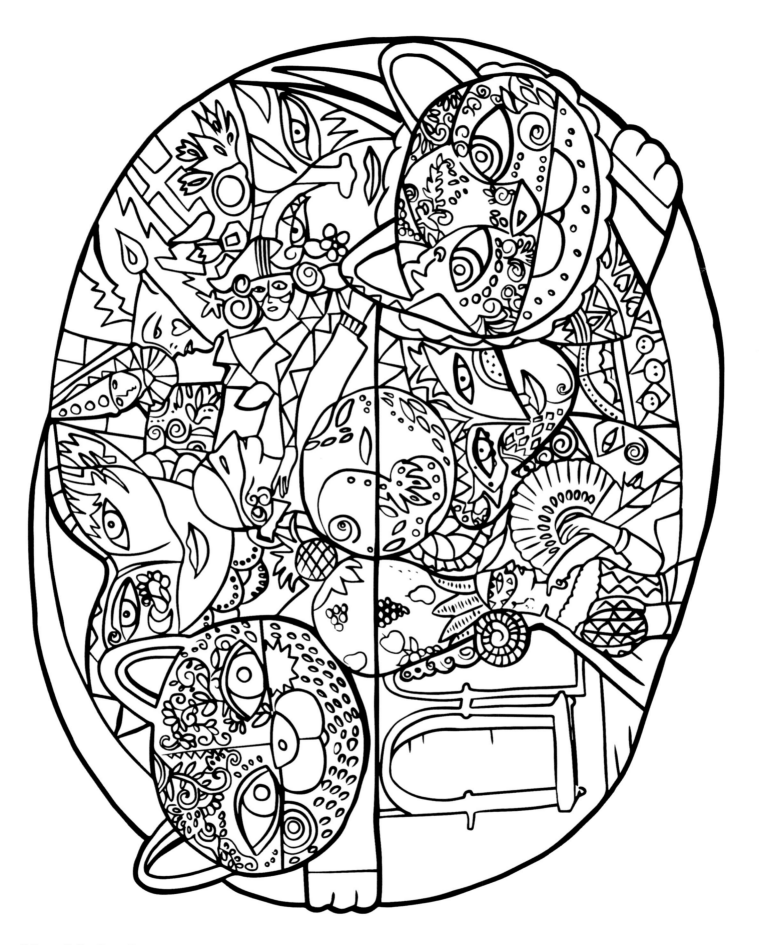

By associating with the cat,
one only risks becoming richer.

—Colette

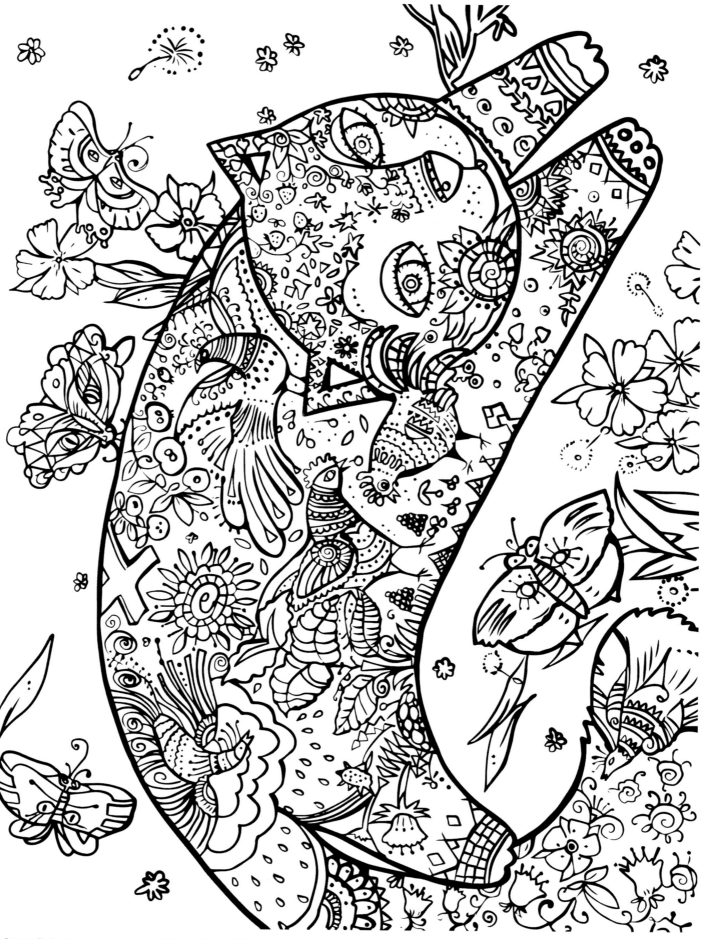

Happiness is not a station you arrive at,
but a manner of traveling.

—Margaret Lee Runbeck

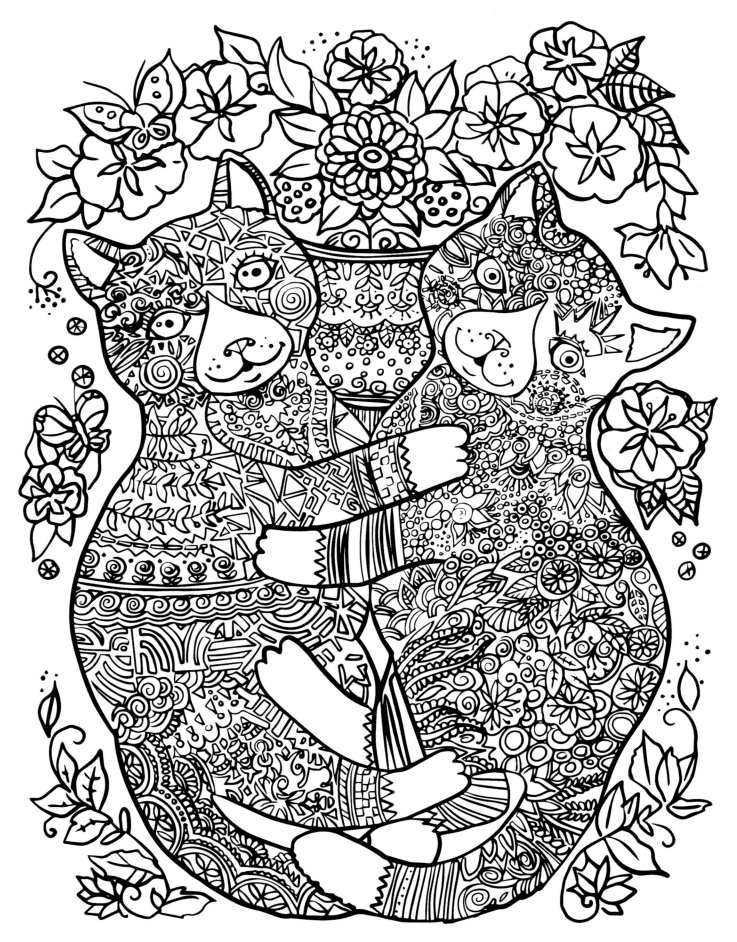

A rose has thorns, a cat has claws;
certainly both are worth the risk.

—Unknown

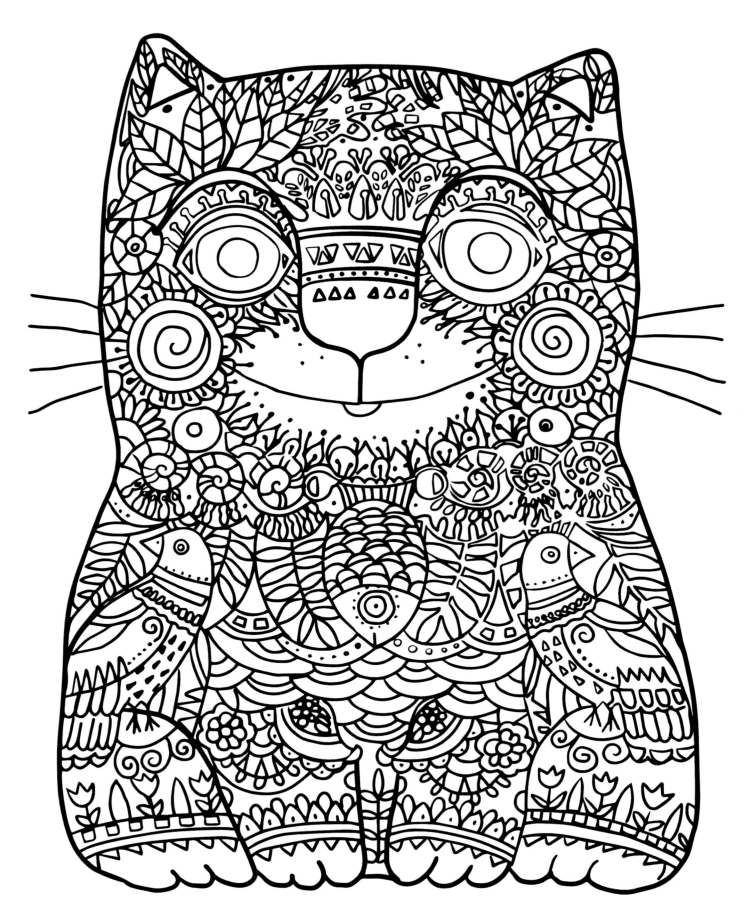

A cat is a puzzle for which
there is no solution.

—Hazel Nicholson

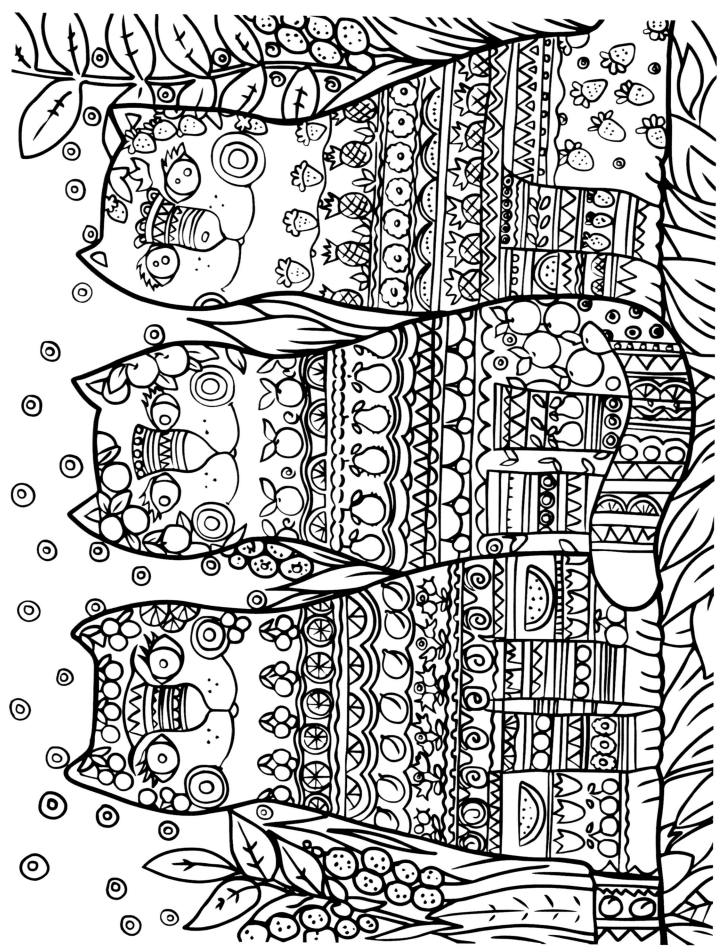

One cat just leads to another.

—Ernest Hemingway

Room for One More

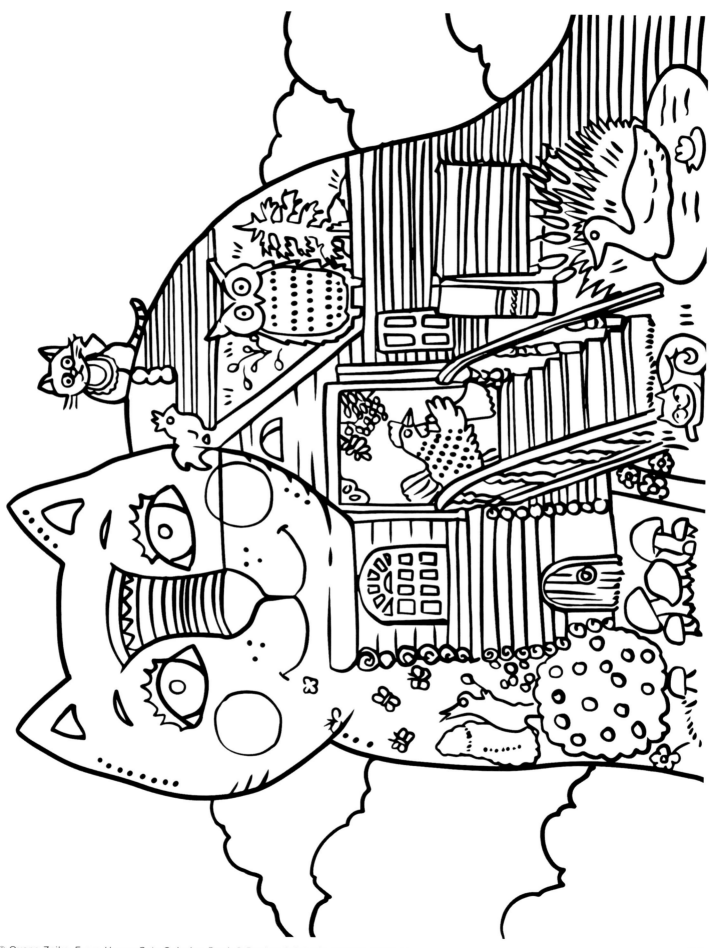

In a cat's eye, all things belong to cats.

—English proverb

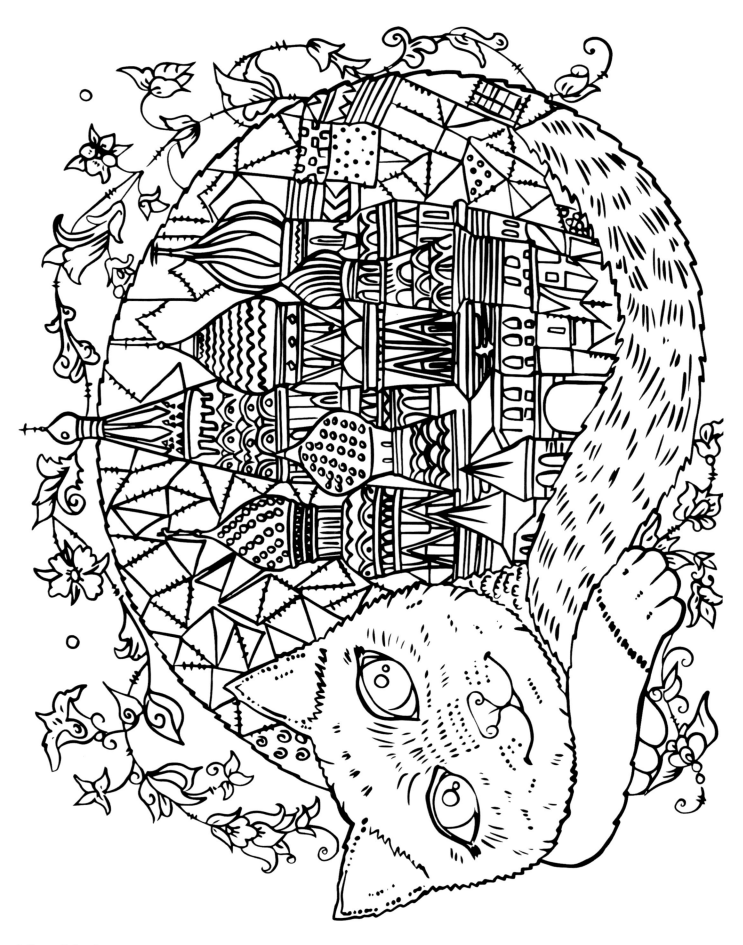

As we all know, cats now rule the world.

—John R. F. Breen

Prince Tom

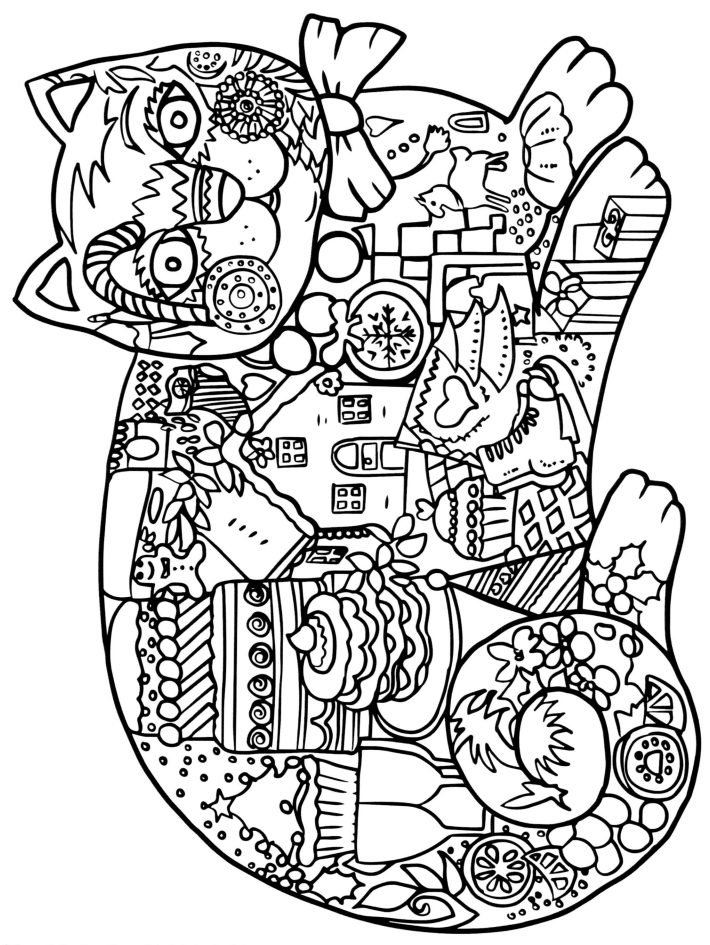

Happiness is something that comes into
our lives through doors we don't
even remember leaving open.

—Rose Wilder Lane

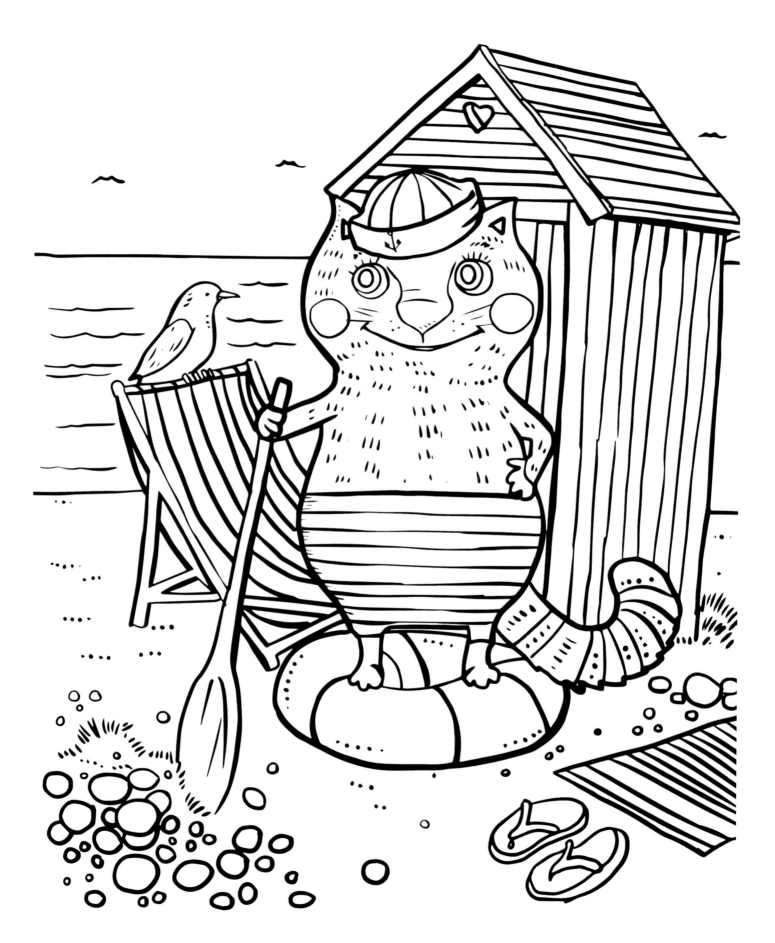

Happiness is a state of activity.

—Aristotle

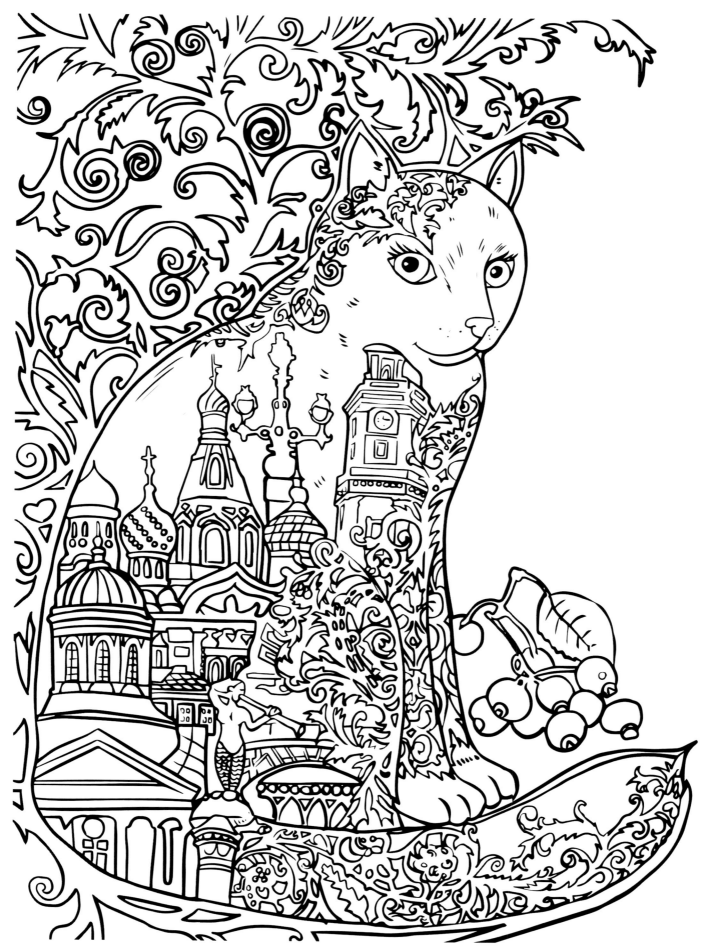

He who lives in harmony with himself
lives in harmony with the universe.

—Unknown

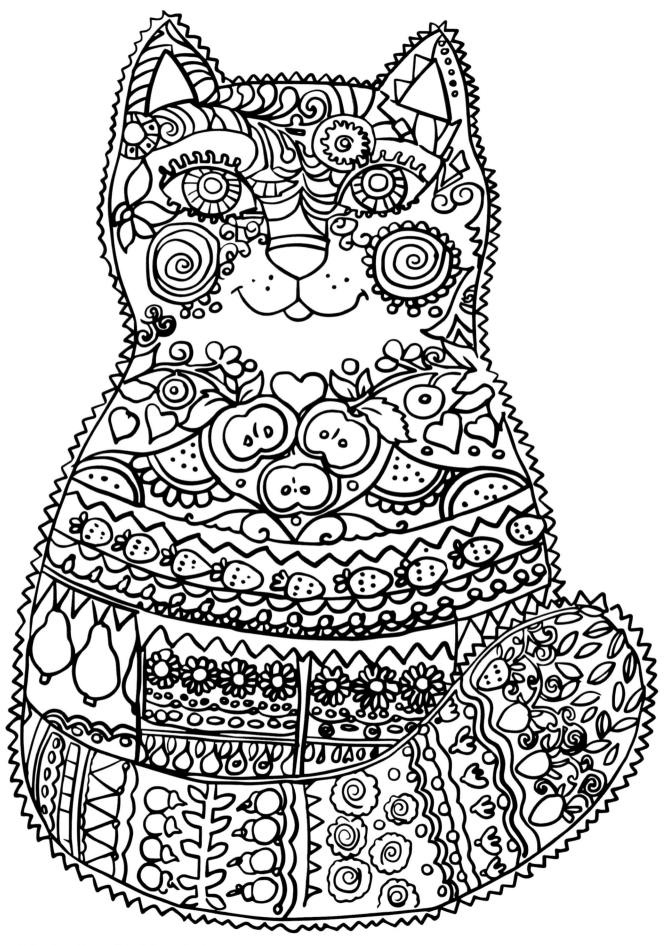

Until one has loved an animal,
a part of one's soul remains unawakened.

—Anatole France

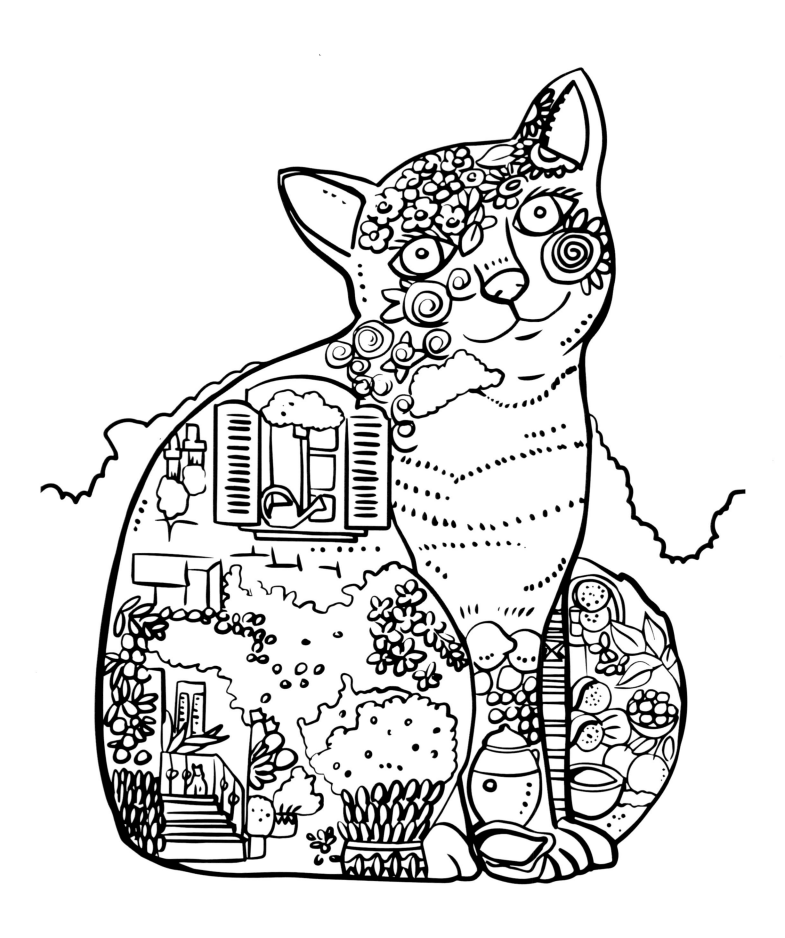

Cats sleep anywhere, any table,
any chair, top of piano, window-ledge,
in the middle, on the edge.

—Eleanor Farjeon

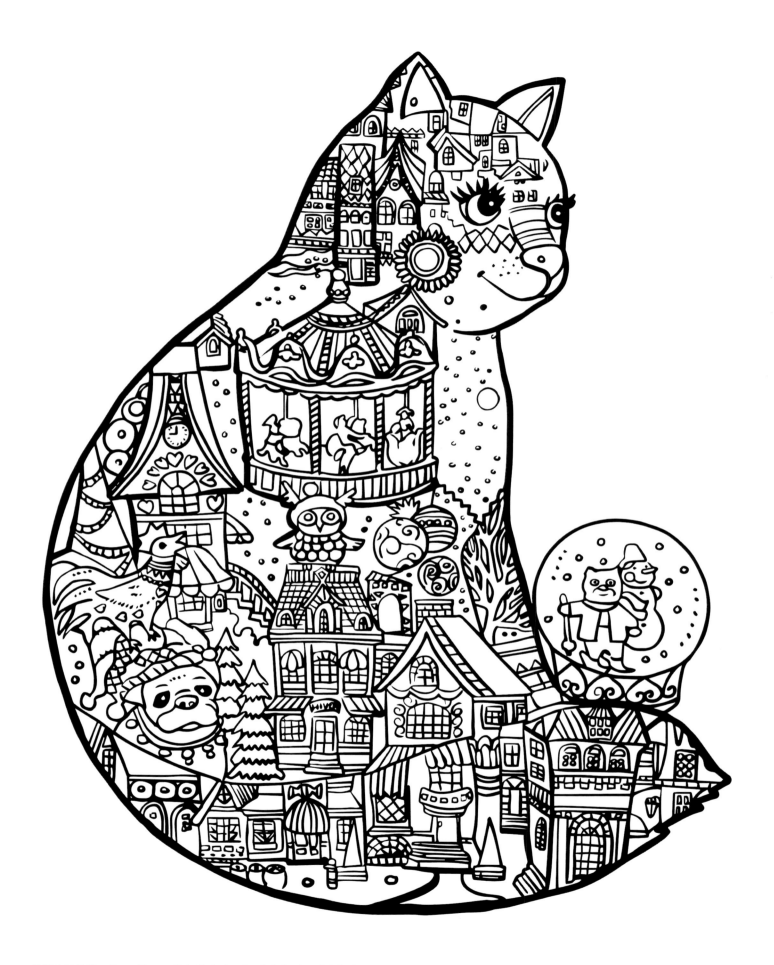

Happiness is a form of courage.

—Holbrook Jackson

Dare to Dream

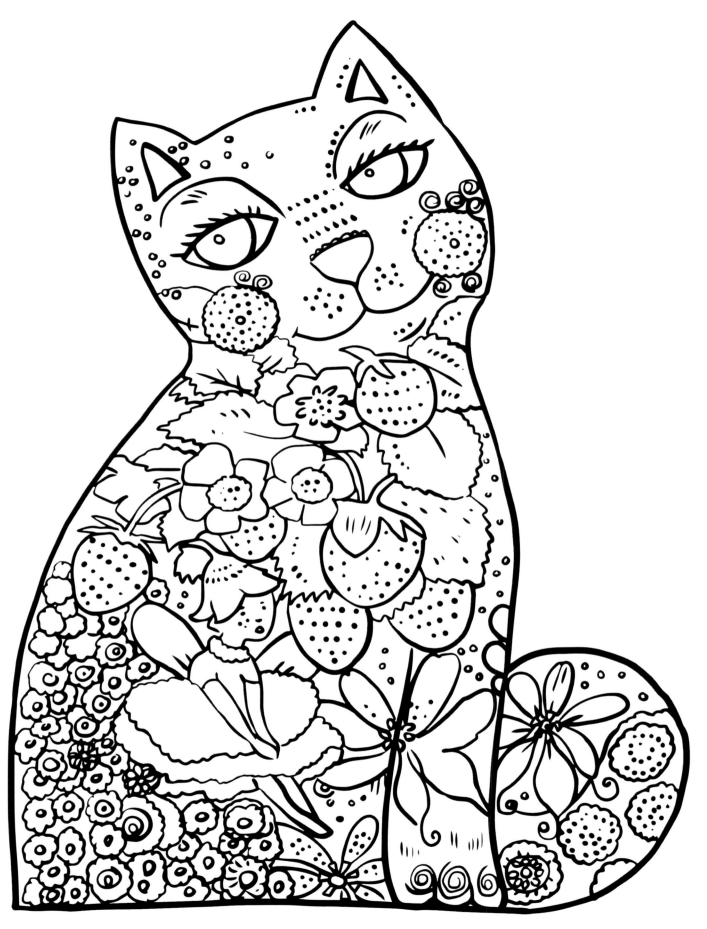

Time you enjoy wasting is not wasted time.

—John Lennon

Fairy Garden

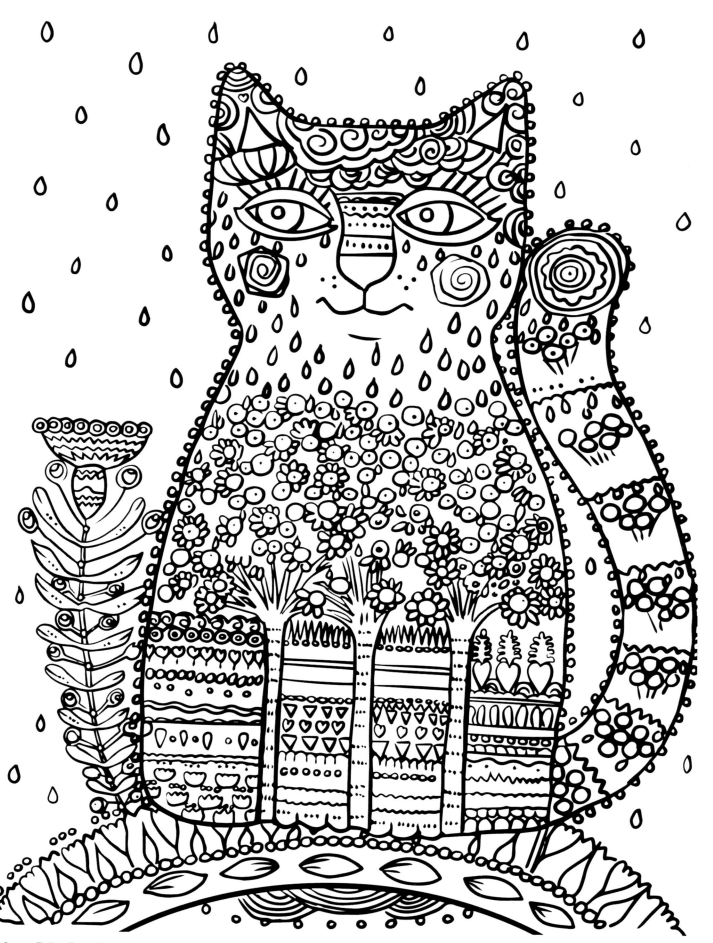

If you think sunshine brings
you happiness, then you haven't
danced in the rain.

—Unknown

Rainy Day

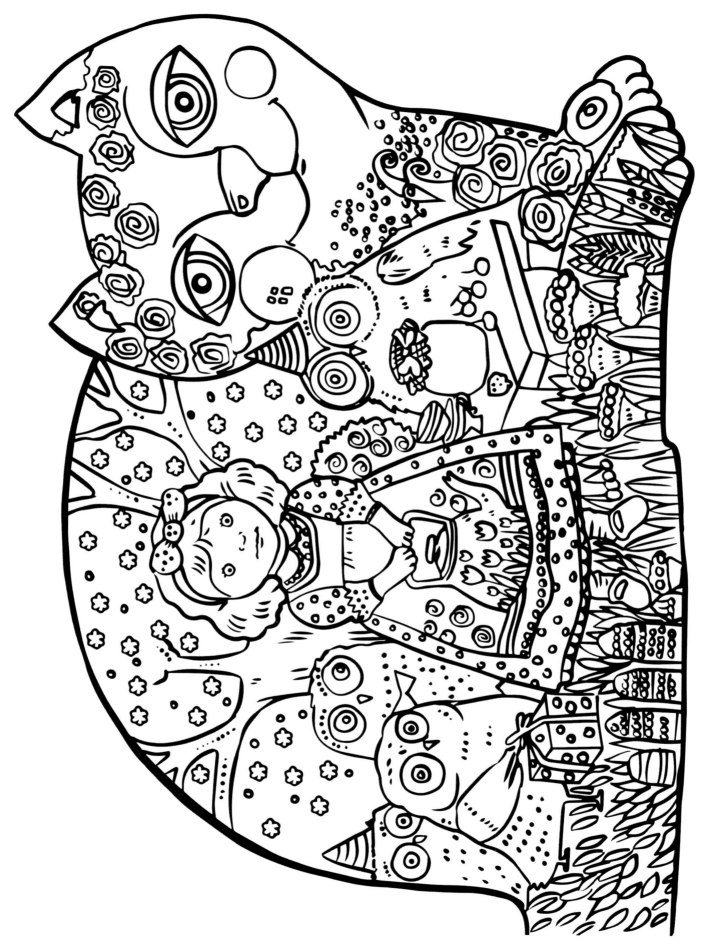

The cat has too much spirit to have no heart.

—Ernest Menaul